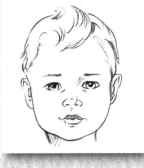

People

From the subtleties of emotion conveyed by facial expressions to the limitless variety of shapes the human form can take, people are some of the most interesting subjects to draw. And knowing how to capture a human likeness is not only interesting and fun, it also gives you the confidence to explore a wider variety of subjects and compositions. This book presents the basic principles of drawing a variety of people, with lessons on facial features, perspective, and composition. You'll also learn how to render figures in action, the differences between adult and child proportions, and simple shading techniques that will bring a sense of realism to all your drawings of people. And if you study and practice the lessons in this book, you'll be surprised at just how quickly your drawings improve. But remember to be patient with yourself and enjoy the learning process. Your efforts will be greatly rewarded!

Getting Started

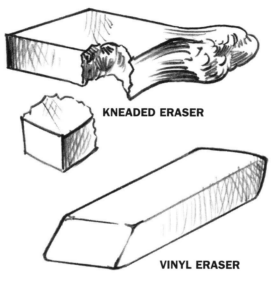

METAL RULER

SANDPAPER PAD

Drawing is just like writing your name. You use lines to make shapes. In the art of drawing, you carry it a bit further, using shading techniques to create the illusion of three-dimensional form.

Only a few basic tools are needed in the art of drawing. The tools necessary to create the drawings in this book are all shown here.

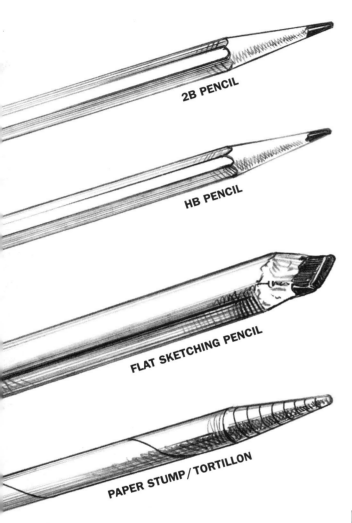

2B PENCIL

HB PENCIL

FLAT SKETCHING PENCIL

PAPER STUMP / TORTILLON

Erasers

Erasers are not only useful for correcting mistakes, but they are also fine drawing tools. Choose from several types: kneaded, vinyl, or rubber, depending on how you want to use the eraser. For example, you can mold a kneaded eraser into a point or break off smaller pieces to lift out highlights or create texture. A vinyl or rubber eraser works well for erasing larger areas.

KNEADED ERASER

VINYL ERASER

Paper

There are many types of paper that vary according to color, thickness, and surface quality (e.g., smooth or rough). Use a sketch pad or inexpensive bond paper for practice. For finer renderings, try illustration or bristol board. Bristol board is available in plate finish, which is smooth, or vellum finish, which has more tooth. As you become more comfortable with drawing techniques, experiment with better quality paper to see how it affects your work.

Other Helpful Materials

You should have a paper blending stump (also known as a tortillon) for creating textures and blends in your drawing. It enhances certain effects and, once covered with lead, can be used to draw smeared lines.

Since you should conserve your lead, have some sandpaper on hand so you can sharpen the lead without wearing down the pencil. You may want to buy a metal ruler, as well, for drawing straight lines. Lastly, a sturdy drawing board provides a stable surface for your drawing.

Final Preparations

Before you begin drawing, set up a spacious work area that has plenty of natural light. Make sure all your tools and materials are easily accessible from where you're sitting. Since you might be sitting for hours at a time, find a comfortable chair.

If you wish, tape the paper at the corners to your drawing board or surface to prevent it from moving while you work. You can also use a ruler to make a light border around the edge of the paper; this will help you use the space on your paper wisely, especially if you want to frame or mat the finished product.

DRAWING PAPER

Pencils

Pencils come in varying degrees of lead, from very soft to hard (e.g., 6B, 4B, 2B, and HB, respectively). Harder leads create lighter lines and are used to make preliminary sketches. Softer leads are usually used for shading.

Flat sketching pencils are very helpful; they can create wide or thin lines, and even dots. Find one with a B lead, the degree of softness between HB and 2B.

Although pencil is the primary tool used for drawing, don't limit yourself. Try using charcoal, colored pencils, crayons, and pastels—they can add color and dimension to your work.

DRAWING BOARD

Shading Techniques

Shading enables you to transform mere lines and shapes in your drawing into three-dimensional objects. As you read through this book, note how the words *shape* and *form* are used. Shape refers to the actual outline of an object, while form refers to its three-dimensional appearance. See the examples below.

This is an oval *shape*.

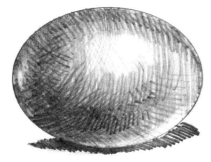

This has a three-dimensional, ball-like *form*.

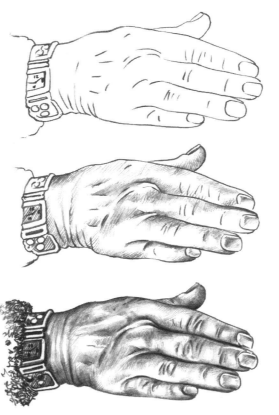

As you shade, follow the angle of the object's surface, and blend to allow the texture to emerge.

As you can see, pencils can be used with sharp, round, flat, and blunt points, and several techniques can be combined on one surface. The paper stump helps smear the lead, making a blend softer. Experiment and see what kinds of textures you can create on your own.

FLAT SKETCH

ROUND SHARPENED FLAT

TIP OF SHARP ROUND

SIDE OF ROUND

BLUNT ROUND

PAPER STUMP/TORTILLON

Make patterns like the ones above using the side, rounded tip, and sharpened point of an HB pencil. Shade backgrounds first; then draw patterns over them. Pressing harder creates darker effects.

Gradual blends like these above can be created using the side of a 2B pencil. Shade in one direction to make the vertical finish on the left. On the right, see that two "blend angles" produce a smoother finish. Start lightly and increase pressure as you work to the right.

Left: Use a sharp-pointed HB to draw this line pattern. **Right:** Shade a light background with a round-pointed HB. Then use a sharp-pointed one to draw the darker, short lines over the background.

Left: Draw groups of randomly patterned lines using a round HB lead. **Right:** Use the side of an HB to shade the background, blend with a paper stump, then add patterned lines over the background.

Left: Create blends and lines like these with a blunt round 2B pencil. **Right:** Use the same technique as the left example, then blend softly with your finger or a paper stump.

Left and right: Make lighter background shading using the side of a 2B. Then apply a little more pressure for the darker patterns, varying the pencil angle.

Pictorial Composition

Creating a good composition is important in any drawing; therefore, let your subject(s) guide you. It's not necessary to place the main subject directly in the center of your composition. For example, the eyes of the girls below are looking in different directions, which determines where the girls are positioned.

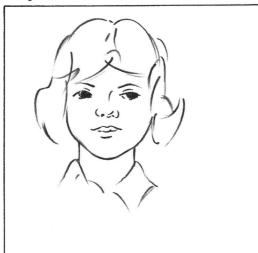

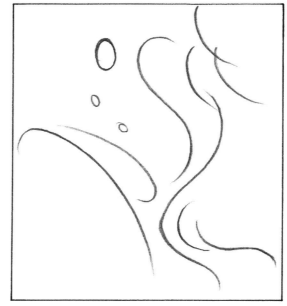

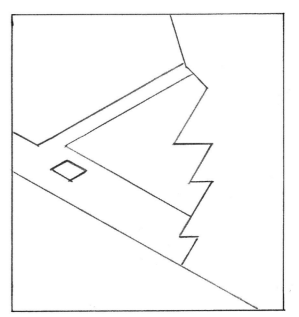

Curved lines are good composition elements—they can evoke harmony and balance in your work. Try drawing some curved lines around the paper. The empty areas guide you in placing figures around your drawing.

Sharp angles can produce dramatic compositions. Draw a few straight lines in various angles, and make them intersect at certain points. Zigzagging lines also form sharp corners that give the composition an energetic feeling.

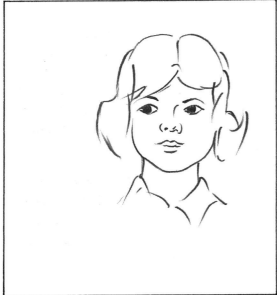

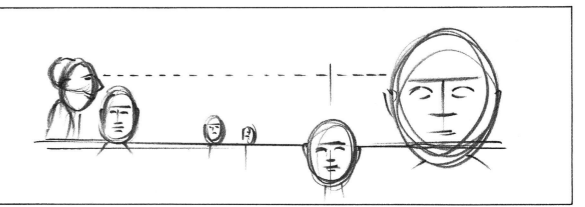

The compositions above and below illustrate how arm position, eyesight direction, and line intersection can guide the eye to a particular point of interest. Using these examples, try to design some of your own original compositions.

Intentionally drawing your subject larger than the image area, as in the example below, is also a unique composition. While part of the image may be cut off, this kind of close-up creates a dramatic mood.

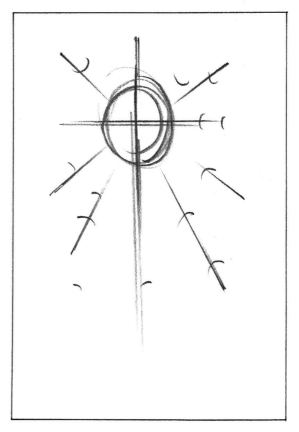

You can create a flow or connection between multiple subjects in a composition by creatively using circles and ellipses, as shown to the right.

People in Perspective

Knowing the principles of perspective allows you to draw more than one person in a scene realistically. It's general knowledge that eye level changes as your elevation of view changes. In perspective, eye level is indicated by the *horizon line*. Imaginary lines receding into space meet on the horizon line at what is known as *vanishing points*. Any figures drawn along these lines will be in proper perspective. Study the diagrams at the right to help you.

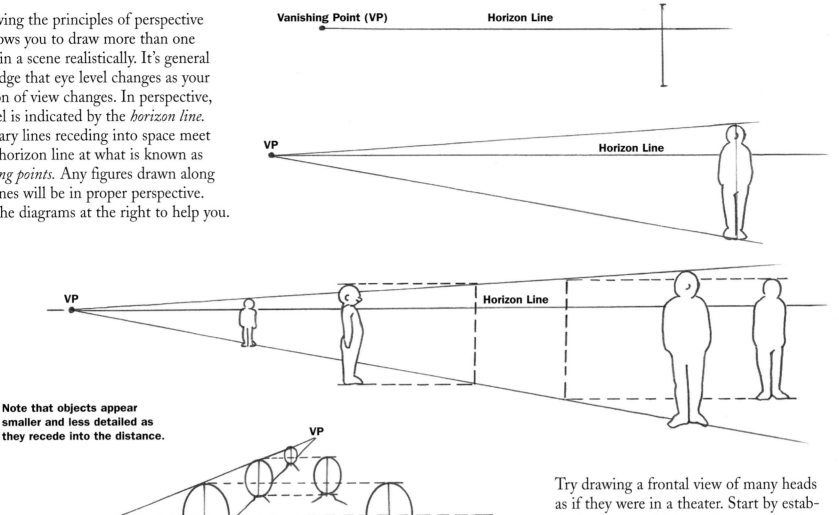

Note that objects appear smaller and less detailed as they recede into the distance.

Try drawing a frontal view of many heads as if they were in a theater. Start by establishing your vanishing point at eye level. Draw one large head representing the person closest to you, and use it as a reference for determining the sizes of the other figures in the drawing.

The technique illustrated to the left can be applied when drawing entire figures, shown in the diagram below. Although all of these examples include just one vanishing point, a composition can even have two or three vanishing points.

If you're a beginner, you may want to begin with basic one-point perspective, shown on this page. As you progress, attempt to incorporate two- or three-point perspective. For more in-depth information, refer to the book *Perspective* (AL13) in Walter Foster's Artist's Library Series.

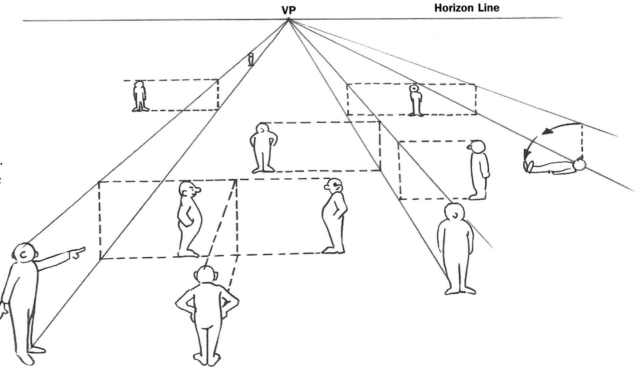

Adult Head Proportions

Learning proper head proportions will enable you to accurately draw the head of a person. Study the measurements on the illustration below left. Draw a basic oval head shape, and divide it in half with a light, horizontal line. On an adult, the eyes fall on this line, usually about one "eye-width" apart. Draw another line dividing the head in half vertically to locate the position of the nose.

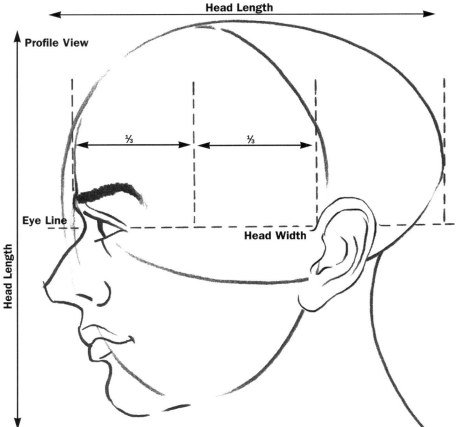

The horizontal length of the head, including the nose, is usually equal to the vertical length. Divide the cranial mass into thirds to help place the ear.

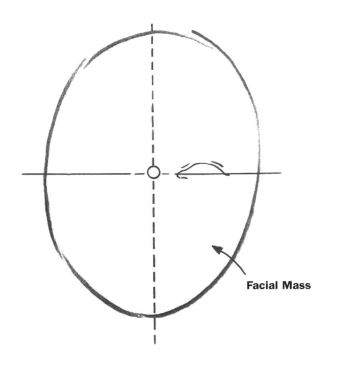

The diagram below illustrates how to determine correct placement for the rest of the facial features. Study it closely before beginning to draw, and make some practice sketches. The bottom of the nose lies halfway between the brow line and the bottom of the chin. The bottom lip rests halfway between the nose and the chin. The length of the ears extends from brow line to the bottom of the nose.

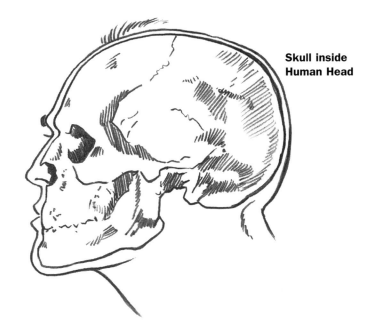

This drawing above illustrates how the skull "fills up" the head. Familiarizing yourself with bone structure is especially helpful at the shading stage. You'll know why the face bulges and curves in certain areas because you'll be aware of the bones that lie underneath the skin. For further information, refer to the Walter Foster book *Anatomy* (HT21).

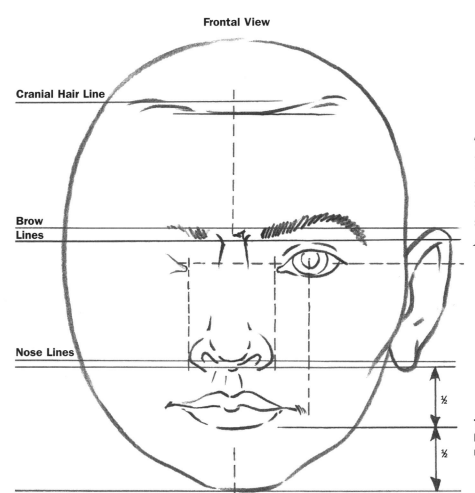

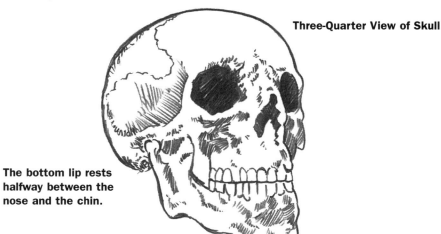

The bottom lip rests halfway between the nose and the chin.

Head Positions & Angles

The boxes shown here correlate with the head positions directly below them. Drawing boxes like these first will help you correctly position the head. The boxes also allow the major frontal and profile planes, or level surfaces, of the face to be discernable. Once you become comfortable with this process, practice drawing the heads shown on this page.

A

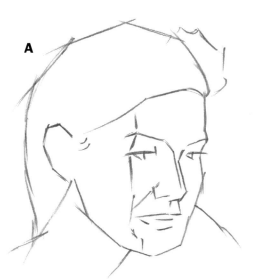

B

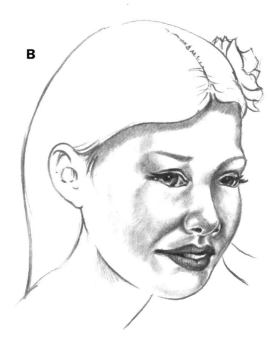

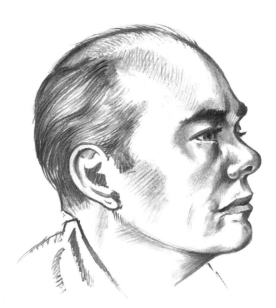

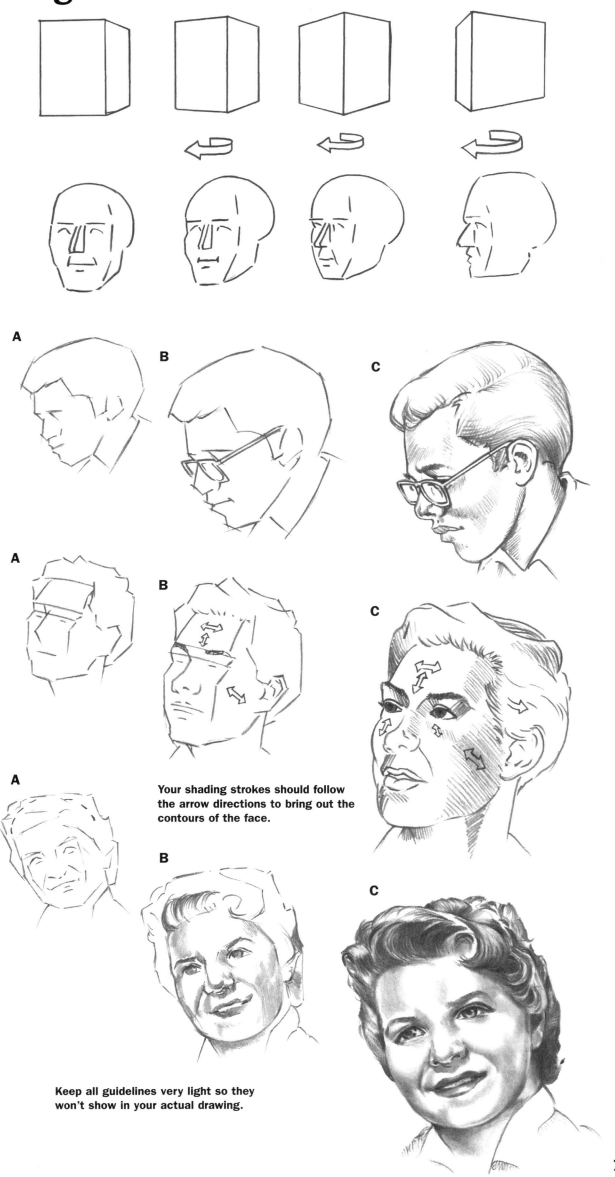

A **B** **C**

A **B** **C**

A

B

Your shading strokes should follow the arrow directions to bring out the contours of the face.

Keep all guidelines very light so they won't show in your actual drawing.

Facial Features—Eyes

The eyes are the most important feature for achieving a true likeness. They also reveal the mood or emotion of the person you are drawing. Study and practice the diagrams showing how to block in frontal and profile views of eyes. Notice that with the profile, you don't begin with the same shape as with the frontal view.

A

Outside Eye Contours (front)

B

A

B

Outside Eye Contours (profile)

A

B

C

A

B

A

B

C

D

C

A

B

C

Even if the rest of the features are correct, if the eyes aren't drawn correctly your drawing won't look like your subject.

A

B

A person's eyes are rarely symmetrical. Look for the subtle differences in each eye to achieve a real likeness.

Shade delicately around the eyes, but make your strokes dark enough to show the eyes' depth and indentation into the face. Very sharp pencils are best for filling in the creases and corners around the eye. These tiny areas (which don't get much light) should be very dark, gradually getting lighter as you shade away from the eye to bring out the contours of the face.

Pay particular attention to the highlights in the eye. They bring life and realism to the drawing.

Eyebrows also play an important part of facial expression. They can be bushy or thin, arched or straight. Study your subject's eyebrows carefully.

A three-quarter angle view can generate a totally different mood, especially if the eyes aren't completely open.

Facial Features—Noses & Ears

Noses can be easily developed from simple straight lines. The first step is to sketch the overall shape as illustrated by the sketches below. Then smooth out the corners into subtle curves in accordance with the shape of the nose. A three-quarter view can also be drawn with this method. Once you have a good preliminary drawing, begin shading to create form.

The nostrils enhance the personality of the nose as well as the person. Make sure the shading inside the nostrils isn't too dark or they might draw too much attention. Men's nostrils are generally angular, while women's nostrils are more gently curved. Observe your subject closely to ensure that each feature of your drawing is accurate.

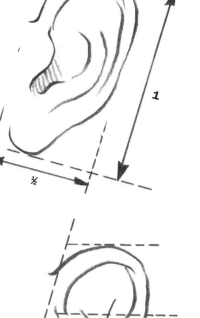

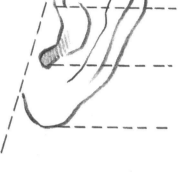

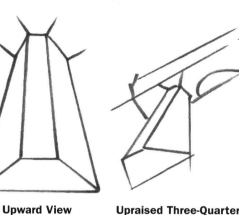

Profile View **Frontal View** **Upward View** **Upraised Three-Quarter View**

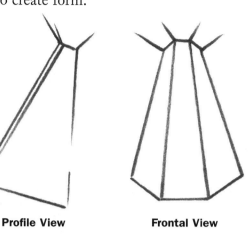

The tip of the nose usually slants upward.

Ears usually connect to the head at a slight angle. To draw an ear, first sketch the general shape, and divide it into thirds, as shown above. Sketch the "ridges" of the ear with light lines, studying where they fall in relation to the division lines. These ridges indicate where to bring out the grooves in the ear; you should shade heavier inside them.

Bone

Cartilage

The lower portion of the nose is made of cartilage, while the upper portion is supported by bone. Also, the tip of the nose usually has a slight ball shape.

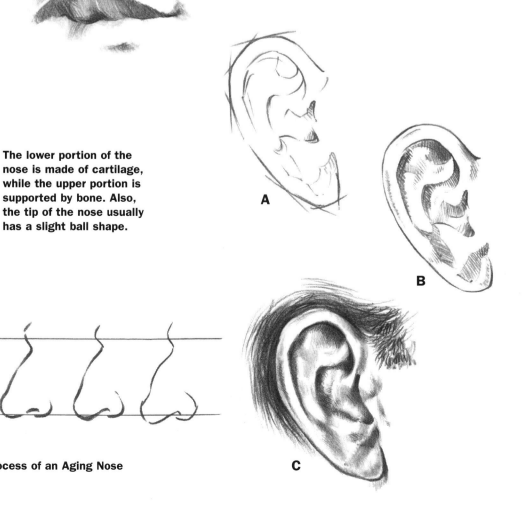

A

B

C

The diagram to the right illustrates how the nose changes as a person ages. In many cases, the tip begins to sag and turn downward. All of these details are important for producing a realistic work.

Process of an Aging Nose

Facial Features—Lips

Lips can be very easy to draw if you study their form closely. For example, notice that the top lip often protrudes slightly over the bottom one. You should also familiarize yourself with the various planes of the lips to shade them well.

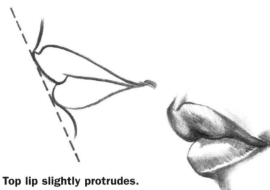

Top lip slightly protrudes.

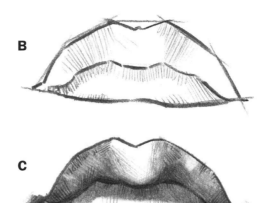

A

B

C

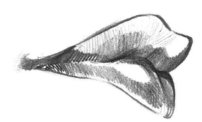

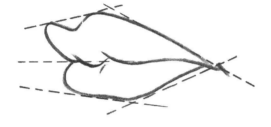

Shade in the direction of the planes of the lips.

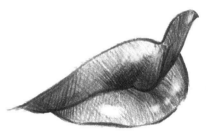

To draw the lips, block in the overall mouth shape with preliminary guidelines. Once you have a satisfactory line drawing, you can begin shading, paying particular attention to where the highlights are located. Highlights enhance the lips' fullness.

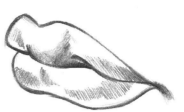

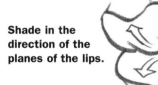

A

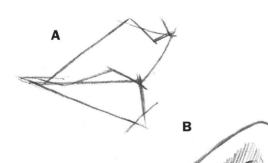

B

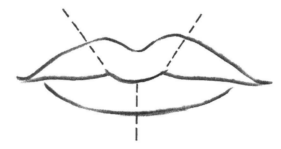

Divide the upper lip into three parts and the lower lip into two parts, as shown above. These light division lines will help you draw the top and bottom lips in proportion with each other.

When drawing men's lips, keep the shading light or they may appear as though they're covered with lipstick. Also, note that men's lips generally do not appear as full as women's.

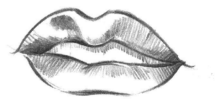

A

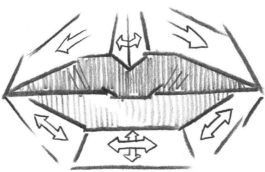

Facial Planes around the Mouth

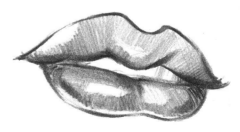

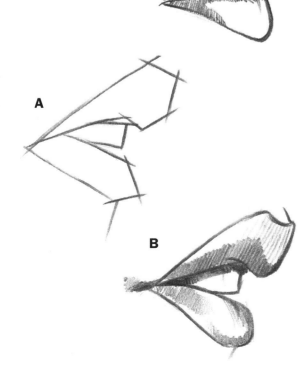

B

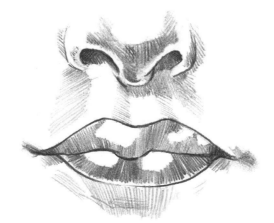

Determine how much detail you'd like to add. For instance, these examples don't show any clearly defined teeth, but how you handle this depends on personal preference.

Facial Features—The Smile

Facial expressions will add life to your artistic work because your drawings will seem more realistic. One of the most basic ways to create expression is with a smile. The illustrations on this page demonstrate steps for drawing smiles.

A
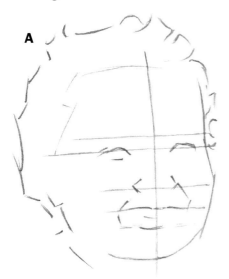

When a person smiles, the rest of the facial features are affected. For example, the bottom eyelids move slightly upward, making the eyes appear smaller.

B
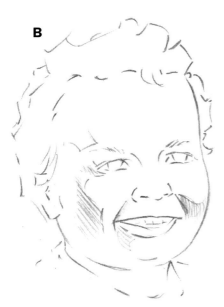

A
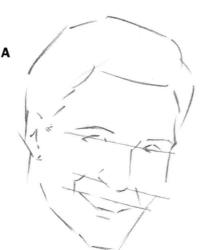

B
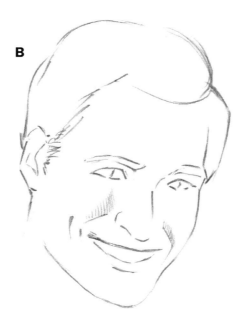

A
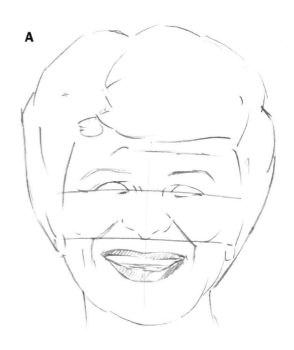

B
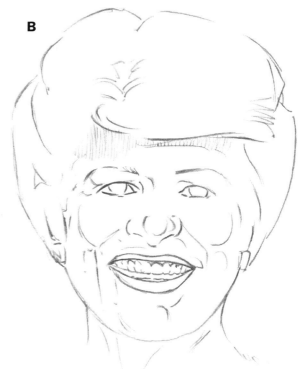

Once you've mastered drawing separate facial features, combine them to build the entire face. Use the head proportions you've already learned to correctly place the features.

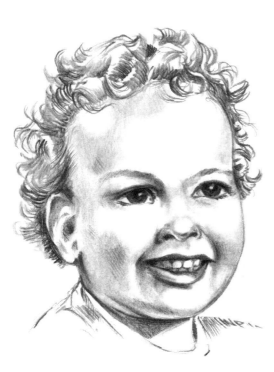

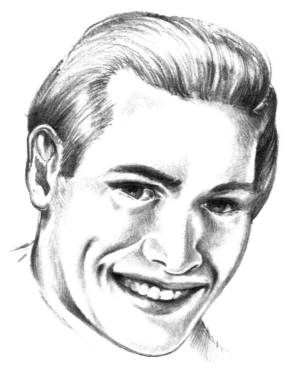

Smiling also causes creases around the mouth and produces more highlights on the cheek area since the cheeks are fuller and rounder. The lips, on the other hand, require fewer highlights because the smile causes them to flatten out somewhat.

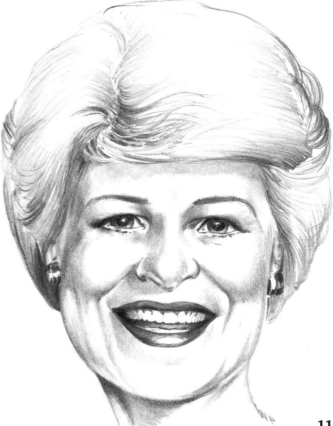

11

The Profile

A profile drawing can be very dramatic. This drawing was done on plate-finish bristol board. With an HB pencil, first sketch the lines to establish the head angle. You might want to use the technique of drawing a box first to position the head, as demonstrated earlier on page 7.

A

B

C

When shading the profile or any view of the face, it's important to recognize the different planes of the face. These are illustrated in the drawing to the right. When you reach the shading stage, use a sharp 2B pencil to fill in darker areas such as wrinkles or creases. Use a paper stump to soften smoother features, such as cheeks.

You can produce a very effective drawing with simple, delicate shading.

Planes of the Face

Although the nose is a prominent part of the profile, make certain it doesn't dominate the entire drawing. Take as much time drawing the other features as you would the nose.

A

B

C

The Three-Quarter View

Although the three-quarter view may seem difficult, it can be drawn by following all of the techniques you've already learned. With an HB pencil, use the proper head proportions to lightly sketch the guidelines indicating where the main features will be located.

A

B

C

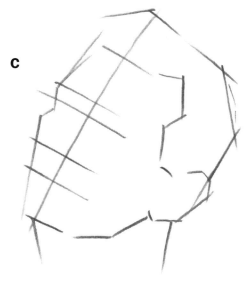

D

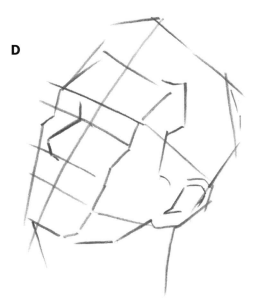

E

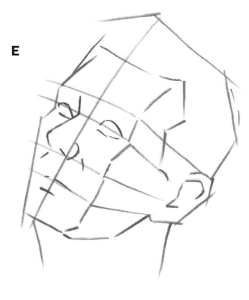

Begin blocking in the shape of the head; then add the hairline, and sketch the ear. Bring out the planes of the face (imagine a box), and position the nose correctly. Sketch the eyes and mouth on the guidelines you've drawn.

F

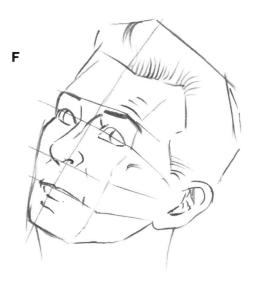

G

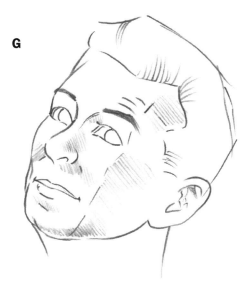

Begin to smooth out your block-in lines, shading lightly with an HB pencil to bring out the face's three-dimensional form. Fill in the creases and details with a sharp-pointed pencil; then use a kneaded eraser molded into an edge or point to pull out the highlights in the hair.

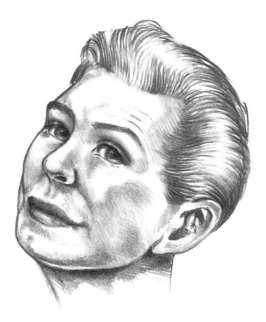

Ask your friends to pose for your drawings. They might get a nice portrait out of it!

Child Head Proportions

The proportions of a child's head differ from those of an adult. Children generally have bigger foreheads; therefore the *eyebrows*—not the eyes—fall on the center horizontal division line. Also, the eyes of youngsters are usually larger and rounder than the eyes of adults.

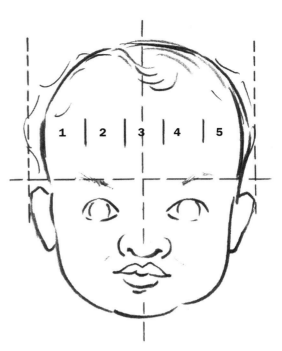

The forehead can be divided into five equal sections with vertical lines. You can position the other facial features in relation to these lines as well.

A

B

½

Brow Line
Eye Line

½

C

The younger the child, the smoother the skin and facial features. Keep your shading even and relatively light.

Children are fascinating drawing subjects; they bring vitality and life to your work.

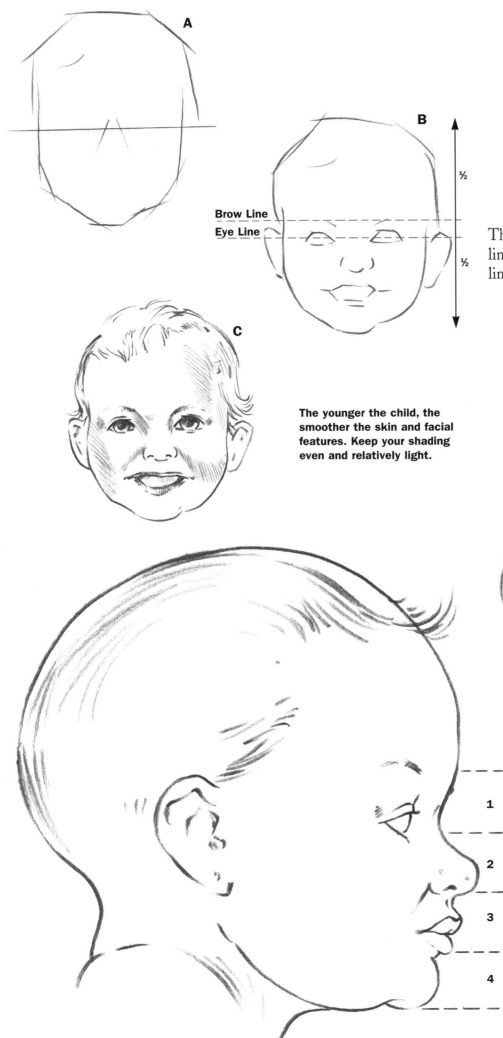

1

2

3

4

To correctly place the features, use the horizontal lines shown to the left to divide the region between the child's brow line and the chin into four equal sections. Study where each feature falls in relation to these division lines.

Practice drawing boys and girls of various ages in different head positions. Keep the shading simple and smooth in these drawings to capture each child's youthful qualities.

A

A

A

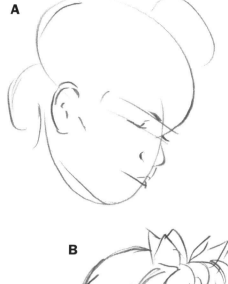

B

B

B

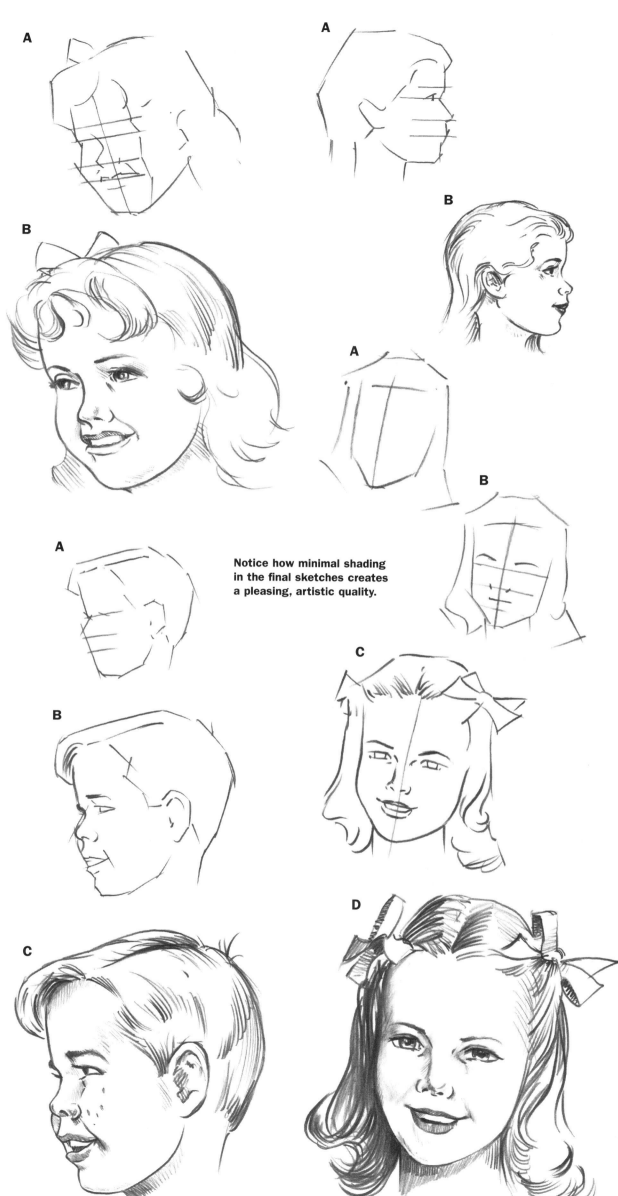

A

A

Notice how minimal shading in the final sketches creates a pleasing, artistic quality.

B

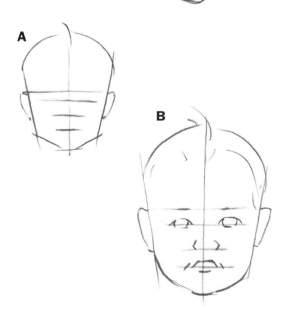

C

A

B

B

C

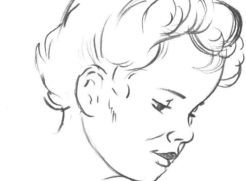

C

C

D

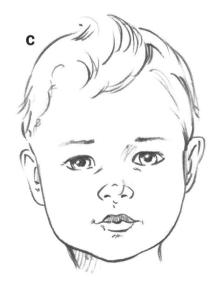

Mature Faces

Portraits of older individuals require more detail because fine lines and wrinkles must be included. Attempt this drawing on vellum-finish bristol board, using an HB pencil to block in your guidelines and facial features. Then find your own drawing model.

Older people generally reveal a lot of character in their faces. Be true to your subjects and try to bring out their essence and personality in your drawing.

B

A

Once you've drawn the basic head shape, lightly indicate where the wrinkles will be. Some of the minor lines can be "suggested" through shading rather than drawing each one. This process can be used for drawing all older individuals.

C

D

Shade delicately with a sharpened 2B pencil. A sharp, dark lead is best for drawing tiny details, such as creases in the lips, fine hair strands, and the corners of the eyes. Your shading should help the features "emerge" from the face. Again, notice the areas where there is no shading and how these areas seem to come toward you. Practice this drawing; then find your own model or a photograph.

When drawing the face of an older man, you can be more aggressive with the lines and shading, because men usually have more rugged features and pronounced creases than women.

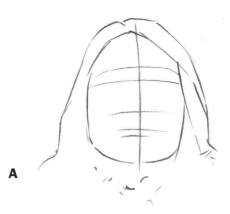

A

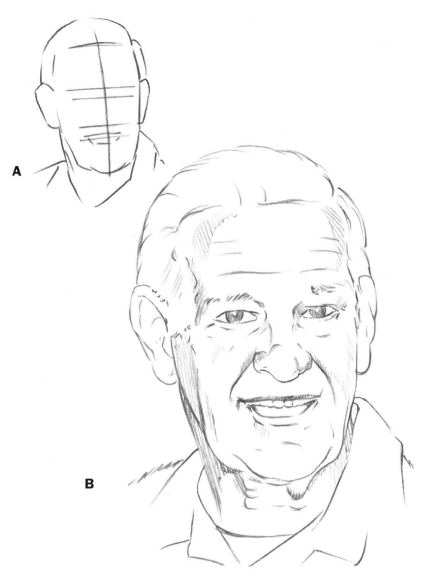

A

B

The Indian's face looks even more rugged and aged than the previous drawing. His cheek bones are also more defined, and he has a wider chin. It's helpful to envision the skull inside this fellow's head to accurately shade the outer features.

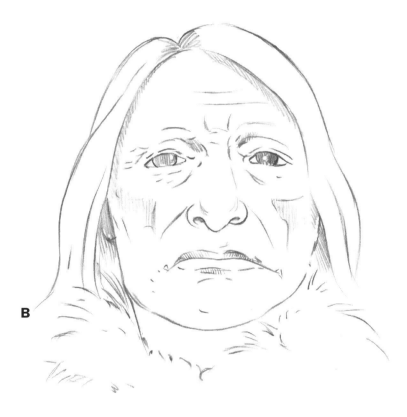

B

Develop the curves and planes of an older man's face with darker shading than for the woman on the previous page. This enhances the rough quality of his skin.

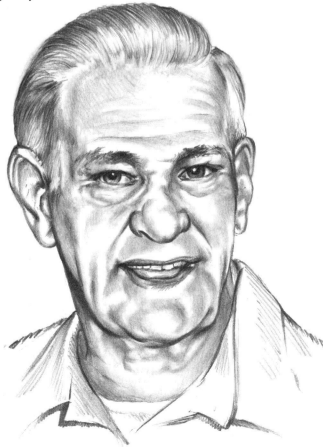

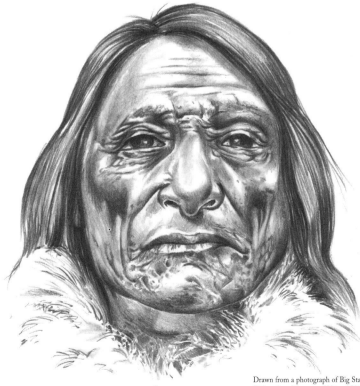

Drawn from a photograph of Big Star.
© American Museum of Natural History, New York.

A paper stump is helpful for the smoother areas of this subject's face, while a sharp 2B will aid in rendering the craggy texture of his chin and the distinct wrinkles around his eyes.

Adult Body Proportions

Just as there are proportion rules for drawing the head, guidelines exist for drawing the human body. You can use average or artistic measurements. The diagrams on this page effectively illustrate the differences between these types of proportions. Study them, and make many practice sketches. As you probably know, an unrealistic figure drawing is easy to spot.

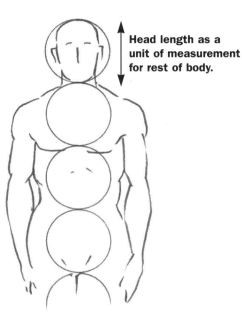

Head length as a unit of measurement for rest of body.

Generally the male figure is widest at the shoulders, while the female is widest at the hips.

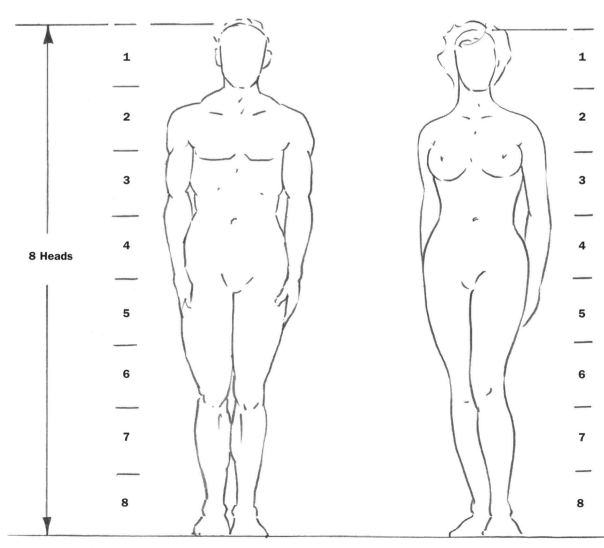

7½ Heads

7½ Heads

Average Proportions

8 Heads

Artistic Proportions

Realistically, most bodies are about 7½ heads tall (average), but we usually draw them 8 heads tall (artistic) because a figure drawn only 7½ heads tall appears short and squatty.

Try drawing some of your own figures. The first renderings may not look quite right, but keep practicing until you get the hang of it. Remember that figure drawing is much easier when you use a reference, such as a live subject or good photograph.

Artistic proportions have been used by artists since the ancient Greek times.

Child Body Proportions

Children of all ages are great drawing subjects. The illustrations at the bottom of the page explain how to use the size of the head as a measuring unit for drawing children of various ages. If you're observing your own model, measure exactly how many heads make up the height of the subject's actual body.

Begin the drawing below by lightly sketching a stick figure in the general pose. Use simple shapes such as circles, ovals, and rectangles to block in the body. Smooth out the shapes into the actual body parts, and add the outline of the clothing.

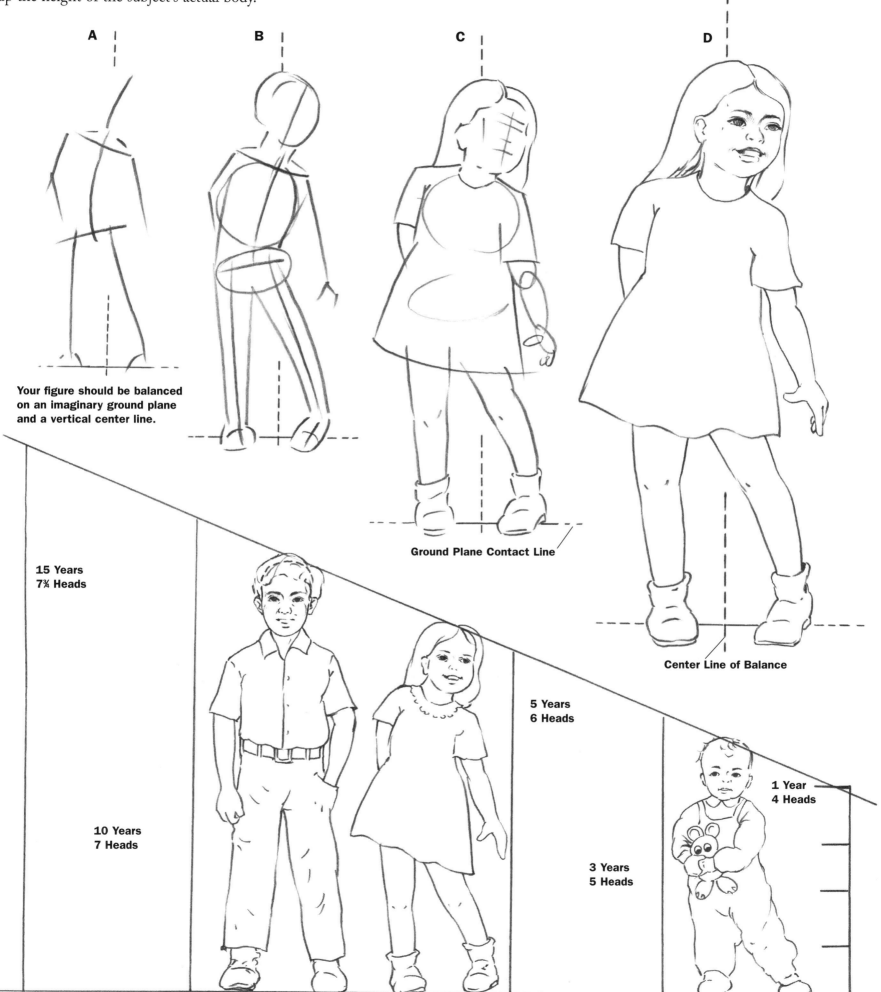

A

Your figure should be balanced on an imaginary ground plane and a vertical center line.

B

C

Ground Plane Contact Line

D

Center Line of Balance

15 Years
7¾ Heads

10 Years
7 Heads

5 Years
6 Heads

3 Years
5 Heads

1 Year
4 Heads

Toddlers are great fun to draw, but since children generally don't remain still for long periods, start out using photographs as models.

The Body

The human body is challenging to render; therefore, it's important to start with a quick drawing of the basic skeletal structure. The human skeleton can be compared to the wood frame of a house; it supports and affects the figure's entire form.

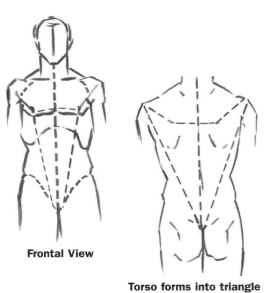

Frontal View

Torso forms into triangle shape.

Basic Skeletal Structure

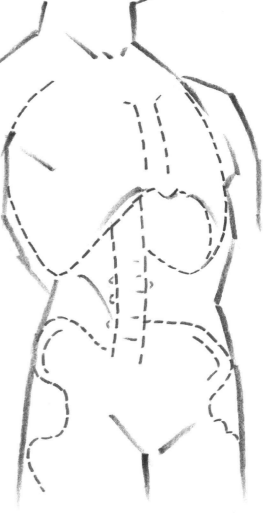

Skeletal Structure inside Body

The frontal view illustrates the planes of the body which are created from the skeleton's form. In men's bodies especially, the torso forms a triangle shape between the shoulder blades and the waist. In women's torsos, the triangle shape is generally less pronounced, and their bodies can even resemble an inverted triangle. In other words, the widest part of the body may be at the hips.

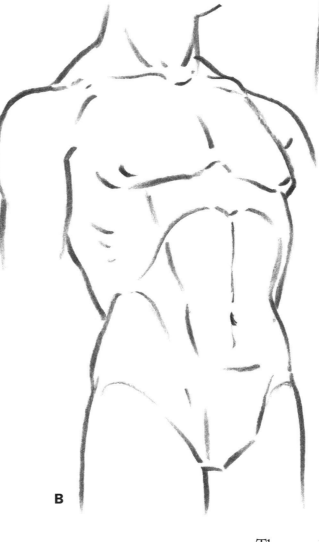

A

B

Michelangelo dissected human cadavers to learn about skeletal and muscle structure!

The muscles also affect the body's form. You might want to study human muscular structure to gain further insight into shading the contours of the body.

20

Hands & Feet

Hands and feet are very expressive parts of the body and are also an artistic challenge. To familiarize yourself with hand proportions, begin by drawing three curved lines equidistant from each other. The tips of the fingers fall at the first line, the second knuckle at the middle line, and the first knuckle at the last one. The third knuckle falls halfway between the finger tips and the second knuckle. The palm, coincidentally, is approximately the same length as the middle finger.

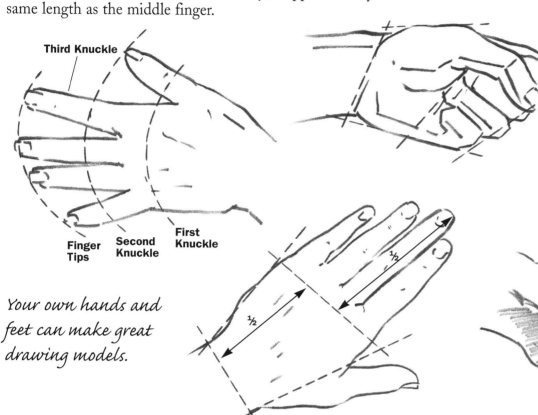

Third Knuckle

Finger Tips

Second Knuckle

First Knuckle

Your own hands and feet can make great drawing models.

Every time a finger bends at the knuckle, a new plane is created. Picture the three-dimensional shape of the hand in various positions. This will help you correctly draw the hand.

Follow the steps shown to draw the feet. Block in the shape in two parts: the main part of the foot and the toes. Once you've drawn a good outline, add minimal shading so you don't call too much attention to the feet.

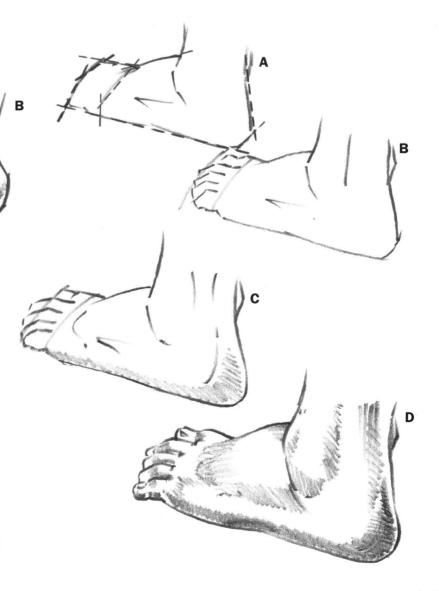

A

B

A

B

C

A

B

D

Clothing Folds

Now that you've mastered drawing the body, you need to know certain techniques that will improve the quality of your work. Drawing realistic clothing folds is one of those techniques.

A

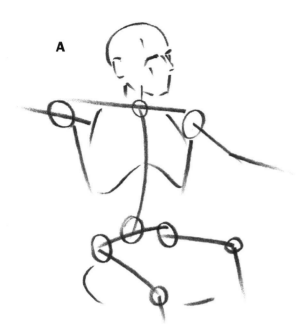

C

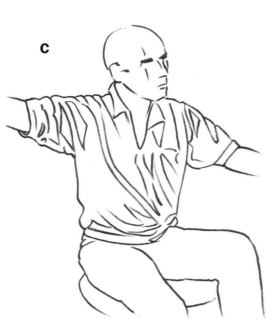

E

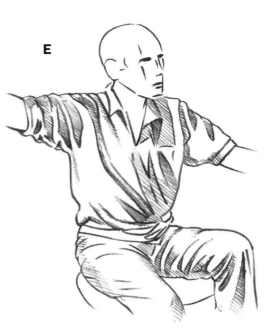

Begin by drawing a stick figure, indicating the location of each joint with some light circles. Then sketch the outline of the clothing, along with preliminary guidelines for the folds; the guidelines will later provide a map for your shading. Indicate only the major folds at this point, while continuing to add light guidelines.

B

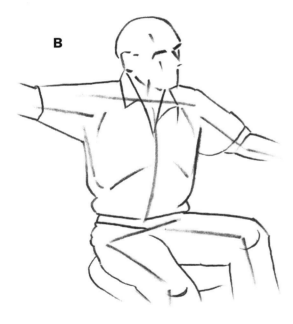

D

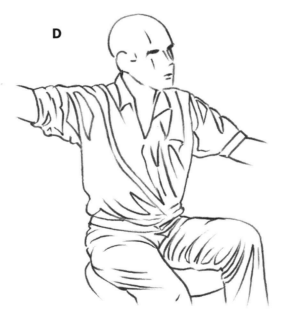

F

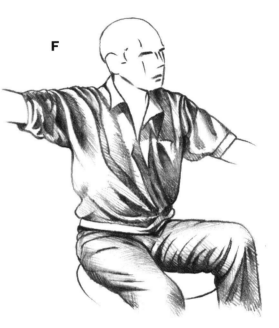

Darken the areas inside the folds with short, diagonal strokes using the point of a 2B pencil. Overlap your strokes at different angles, making them darker towards the center of the folds. Use a paper stump for the finishing touches, blending the edges of the folded areas. You might also want to leave some shading lines to give the drawing an artistic feel.

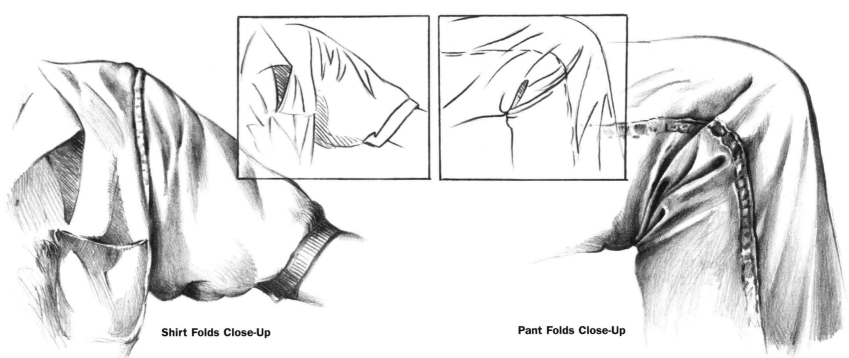

Shirt Folds Close-Up

Pant Folds Close-Up

Foreshortening

Foreshortening allows you to create the illusion of an object coming toward you in space. While the principles of perspective still exist, body parts are more difficult to draw in this manner because they don't have straight edges. In addition, the body proportions are somewhat skewed, or shortened, in a drawing that includes foreshortened subjects.

A

B

The arm resting on the keyboard appears to be receding back into space. The parts of the body closest to you should be shaded the least because they have the most light on them. Also keep in mind that as objects move farther away, they become less detailed and more blurred.

A

With crossed legs, most of the shading falls on the part of the leg farthest away, enhancing the perception of depth in the drawing. Be certain to rough in both legs and the major folds correctly before you begin shading.

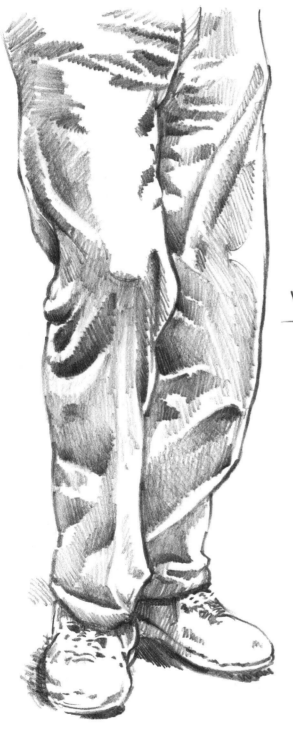

Foreshortening means you are shortening what is coming forward. Notice at the dinner table, when someone passes you something, how his or her arm is foreshortened.

Movement & Balance

Another way to make drawings more realistic is to draw the figures in action. Since people hardly ever sit or stand still, your figure drawings of them shouldn't either. You can begin by using simple sketch lines to lay out the dominant action of the figure.

A

Line of Action

A

B

B

Center Line of Balance

Try employing an imaginary *center line of balance* that seems to hold or balance the figure in its position. Otherwise, the figure may look as though it's going to fall over. The best way to achieve balance is to place approximately the same amount of weight on either side of this center line.

A

B

Line of Action

Another tip is to draw a line that represents the spine of the figure in its action pose; you can develop the pose from this *line of action*. Using both the center line of balance and the line of action help establish effective action figure drawings.

No matter what position a figure takes, you can always find a center of balance, illustrated by the dotted lines on these examples.

Bending & Twisting Figures

When people are involved in something active, they bend and twist their bodies. You should be able to render these movements in your drawings. Clothing helps convey the appearance of a twisting body because the folds form into a twisting design.

When drawing figures in a twisting motion, use what you've already learned about shading folds, but keep in mind that folds on a twisting body will be tighter than folds on a person in a still pose.

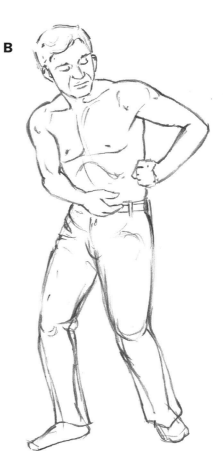

B

A

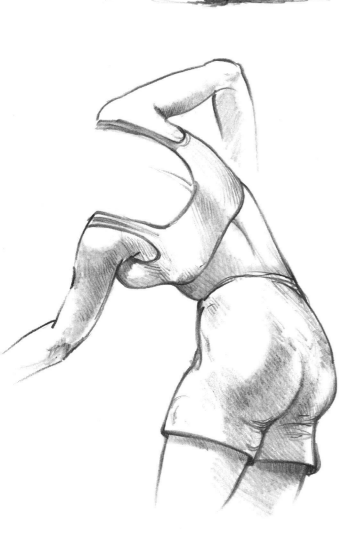

Folds form a twisting pattern.

Don't forget that you can make terrific drawings from photographs too.

To accurately position the active body, sketch some guidelines to indicate the angles of the shoulders, hips, and knees, as shown in the examples.

B

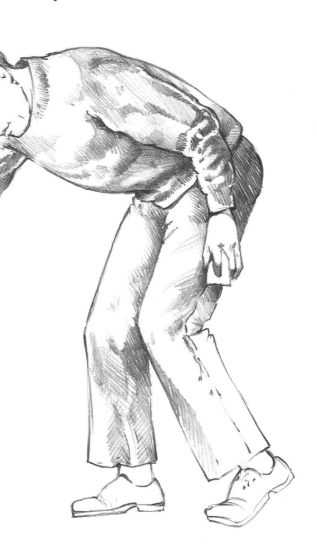

A

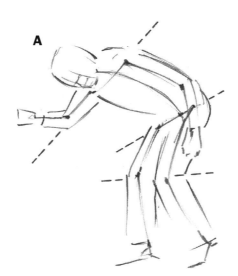

Figures in Action

Before drawing this ballerina, lightly sketch the center line of balance, as well as the action line representing the shape of her spine. Start out with straight lines to lay out her body parts in correct proportion, eventually smoothing out the lines in accordance with her body contours.

When you reach the stage of drawing the dancer's facial features, it's important that her expression corresponds with the feeling of her pose.

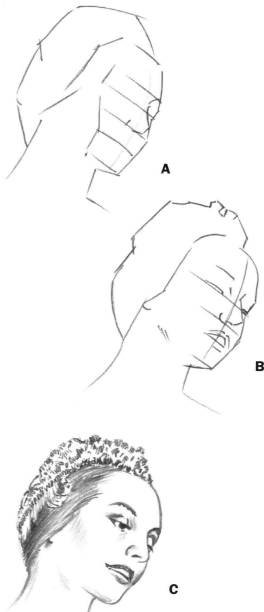

The position of this subject's hands also enhances her serene, graceful mood. Just as the ballerina appears delicate, so should the shading you apply on both her skin and costume. In other words, keep your shading minimal.

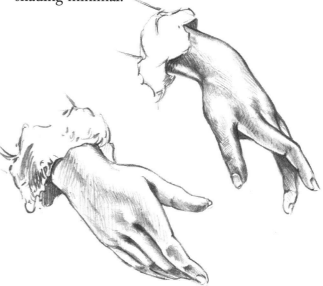

For this drawing, it's important to incorporate all of the drawing concepts explained in this book: head and body proportions, center of balance, drawing hands and feet, clothing folds, and action poses.

Notice that the line of action can be the same for two figures in different poses. This is illustrated in the sketches of the tennis players below.

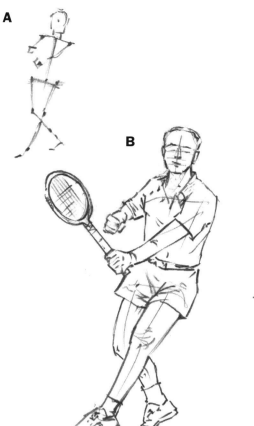

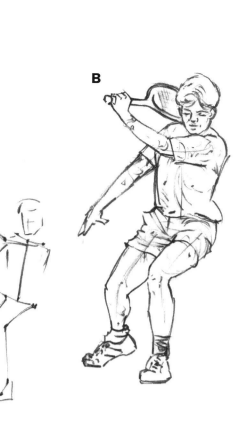

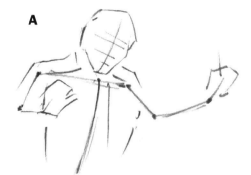

Partial figures, like the conductor, are another challenge. In drawings like these, pay particular attention to the angles of the arms, shoulders, and head—they determine the pose and mood of the person.

A

B

C

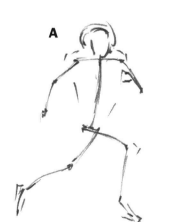

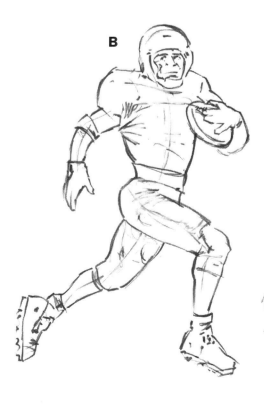

Try combining two figures together in an action pose, such as these ballet dancers. Once you've blocked in one figure, use it as a reference for blocking in the other one. Remember that you want the figures to appear as part of the same drawing, and not like two people drawn separately and then placed together. It's important to develop the shading for both figures at the same time.

Sports Figures in Action

Drawing figures in playing sports is a great way to practice all of the techniques you've learned. It's especially important to sketch the line of action in such dramatic poses because the body often stretches, bends, and twists in all sorts of contortions during these activities.

Angles will play a fundamental role in effectively rendering these figures. Use your knowledge of proportions extensively to capture the body movements.

A

A

B

B

A

B

A

B

People playing sports often display expressions that contort their facial features, such as looks of grimace, shock, joy, or pain.

Children in Action

The same principles of drawing adults in action can be applied to drawing children. But remember, children's arms and legs are usually pudgier than those of an adult, and the proportions of children's bodies are different.

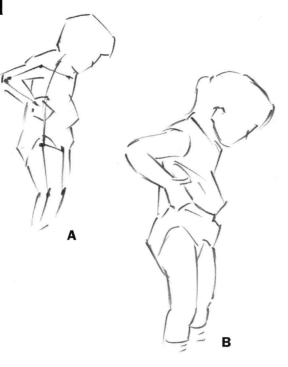

A

B

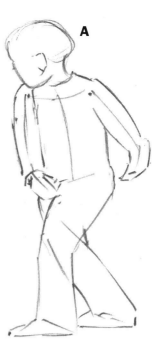

A

B

A

B

Recognize how the line of action differs from the boy jumping for the ball and the girl gathering flowers. Also, adding a ground, field, or river also enhances your work by providing a nice background for your subject.

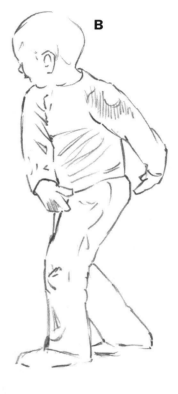

A

B

Before using children in public places as drawing models, it's a good idea to get their parents' permission to do so.

A

B

C

C

There is nothing better than the simple innocence of a child at play. Try to bring out this quality in your drawings.

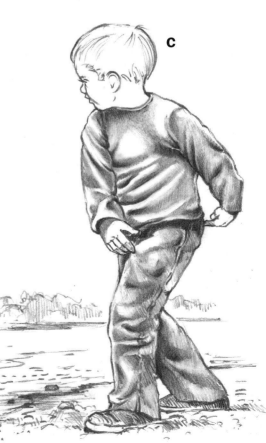

Applying Your Skills

Now that you've mastered all of the techniques in this book, you can incorporate them into one finished work. As you can see, this drawing demonstrates principles of perspective, line of action, and center of balance. It also illustrates successful renderings of figures bending and twisting, sitting, and moving in a variety of action poses. It's important that you attempt to draw a challenging work like this to improve your artistic skills. On location, record your subjects with quick simple lines, creating a reference for a tighter, more polished work back at home. Remember, success requires patience and a lot of practice.

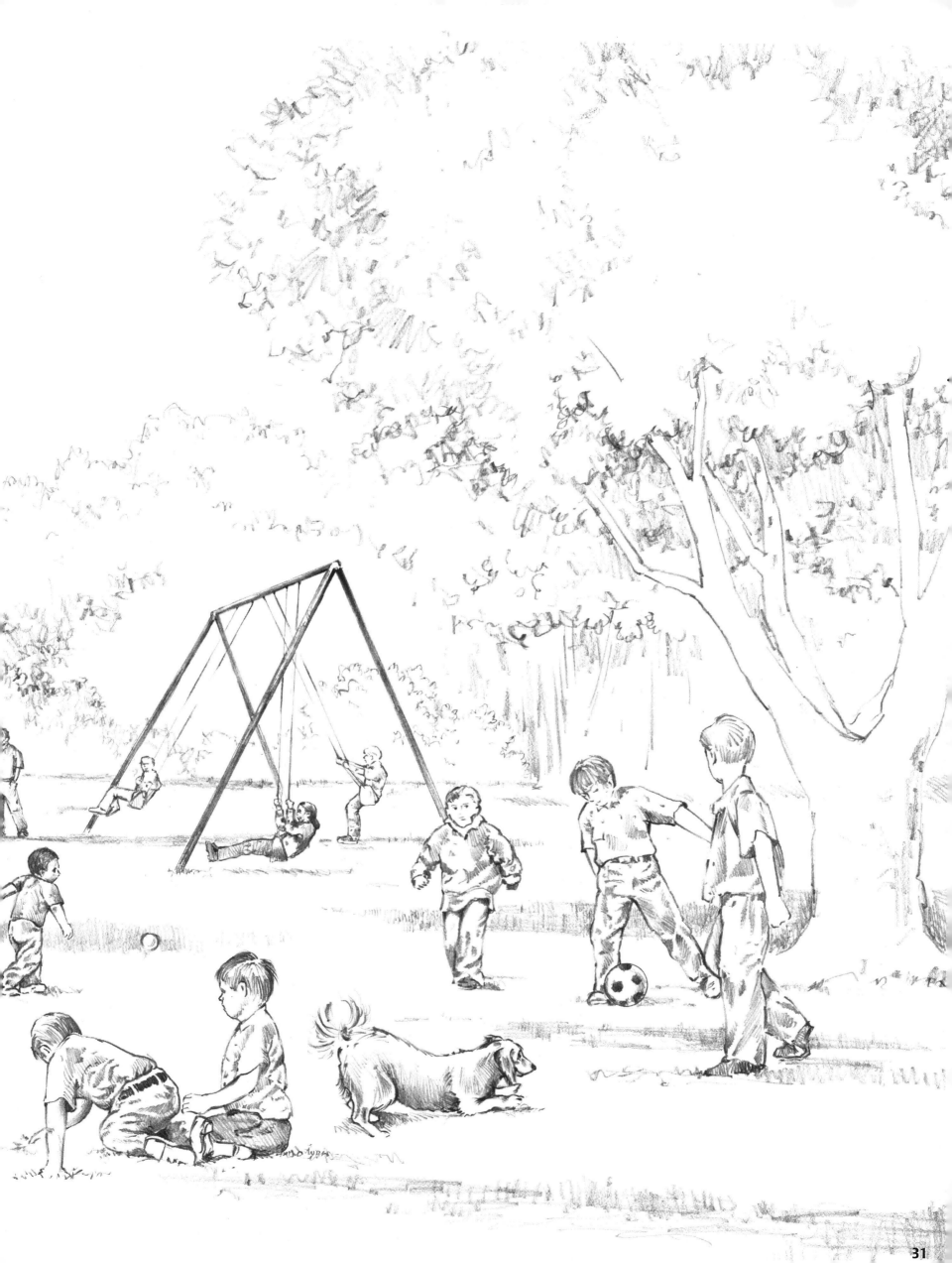

Walter Foster Art Instruction Program

THREE EASY STEPS TO LEARNING ART

Beginner's Guides are specially written to encourage and motivate aspiring artists. This series introduces the various painting and drawing media—acrylic, oil, pastel, pencil, and watercolor—making it the perfect starting point for beginners. Book One introduces the medium, showing some of its diverse possibilities through beautiful rendered examples and simple explanations, and Book Two instructs with a set of engaging art lessons that follow an easy step-by-step approach.

How to Draw and Paint titles contain progressive visual demonstrations, expert advice, and simple written explanations that assist novice artists through the next stages of learning. In this series, professional artists tap into their experience to walk the reader through the artistic process step by step, from preparation work and preliminary sketches to special techniques and final details. Organized by medium, these books provide insight into an array of subjects.

Artist's Library titles offer both beginning and advanced artists the opportunity to expand their creativity, conquer technical obstacles, and explore new media. Written and illustrated by professional artists, the books in this series are ideal for anyone aspiring to reach a new level of expertise. They'll serve as useful tools that artists of all skill levels can refer to again and again.

Walter Foster products are available at art and craft stores everywhere.
For a full list of Walter Foster's titles, visit our website at www.walterfoster.com
or send $5 for a catalog and a $5-off coupon.

WALTER FOSTER PUBLISHING, INC.
23062 La Cadena Drive
Laguna Hills, California 92653
Main Line 949/380-7510
Toll Free 800/426-0099

www.walterfoster.com